Elegant Display Alphabets

Elegant Display Alphabets

100 COMPLETE FONTS

SELECTED AND ARRANGED BY

DAN X. SOLO

FROM THE SOLOTYPE TYPOGRAPHERS CATALOG

DOVER PUBLICATIONS, INC. · NEW YORK

Published in Canada by General Publishing Company, Ltd., 30 Lesmill Road, Don Mills, Toronto, Ontario.
Published in the United Kingdom by Constable and Company, Ltd., 3 The Lanchesters, 162–164 Fulham Palace Road, London W6 9ER.

Elegant Display Alphabets: 100 Complete Fonts is a new work, first published by Dover Publications, Inc., in 1992.

DOVER *Pictorial Archive* SERIES

This book belongs to the Dover Pictorial Archive Series. You may use the letters in these alphabets for graphics and crafts applications, free and without special permission, provided that you include no more than six words composed from them in the same publication or project. (For any more extensive use, write directly to Solotype Typographers, 298 Crestmont Drive, Oakland, California 94619, who have the facilities to typeset extensively in varying sizes and according to specifications.)

However, republication or reproduction of any letters by any other graphic service, whether it be in a book or in any other design resource, is strictly prohibited.

Manufactured in the United States of America
Dover Publications, Inc., 31 East 2nd Street, Mineola, N.Y. 11501

Library of Congress Cataloging-in-Publication Data

Elegant display alphabets : 100 complete fonts / selected and arranged by Dan X. Solo from the Solotype Typographers catalog.
 p. cm. — (Dover pictorial archive series)
 ISBN 0-486-26963-9 (pbk.)
 1. Type and type-founding—Display type. 2. Printing—Specimens. 3. Alphabets. I. Solo, Dan X. II. Solotype Typographers. III. Series.
Z250.5.D57E43 1992
686.2'24—dc20
 91–27012
 CIP

Albertus Light

ABCDEFGHIJKL MNOPQRSTUV WXYZ&;!?

abcdefghijklmno pqrstuvwxyz

$1234567890

American Gothic Light

ABCDEFGHIJ
KLMNOPQRST
UVWXYZ

abcdefghijklmn
opqrstuvwxyz

&;!?$

1234567890

Andrich Minerva

ABCDEFGHIJ
KLMNOPQRST
UVWXYZ

abcdefghijklmn
opqrstuvwxyz

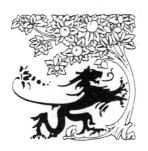

&1234567890$;!?

Announcement Roman

ABCDEFGHI
JKLMNOPQRST
UVWXYZ

abcdeffghijklmno
pqrstuvwxyz

BGDGMNP
RTVW

$1234567890&;!?

Antique Olive Light

ABCDEFGHIJKL
MNOPQRSTU
VWXYZ&;!?

abcdefghijklm
nopqrstuvwxyz

1234567890$

Antique Roman Shaded

ABCDEFGHIJK
LMNOPQRST
UVWXYZ

abcdefghijklmno
pqrstuvwxyz

1234567890

ARCHITECT SLIM

ABCDEFGHI

JKLMNOPQR

STUVWXYZ

&;!?

1234567890

Artcraft

ABCDEFGH
IJKLMNOPQR
STUVWXYZ

abcdeffghijklm
nopqrstuvwxyz
&;!?
1234567890$

Athenaeum

ABCDEFGHIJK
LMNOPQRST
UVWXYZ

abcdefghijklmn
opqrstuvwxyz

&

$1234567890;!?

Attraction Light

ABCDEFGHIJKL
MNOPQRST
UVWXYZ

abcdefghijklmn
opqrstuvwxyz

&1234567890$;!?

Aurelio Light

ABCDEFGHIJKL
MNOPQRSTUV
WXYZ &;!?

abcdefghijklmno
pqrstuvwxyz

1234567890

Auriol Condensed

ABCDEFGHIJKL
MNOPQRSTU
VWXYZ

abcdefghijklmno
pqrstuvwxyz

etc.

1234567890

Baker Signet

ABCDEFGHIJK
LMNOPQRSTU
VWXYZ

abcdefghijklmn
opqrstuvwxyz

$1234567890&;!?

Bauer Text Light

ABCDEFGHIJKLM
NOPQRSTUVW
XYZ&;!?
abcdefghijklmnopq
rstuvwxyz

1234567890

Belvedere Light

ABCDEFGH
IJKLMNOPQR
STUVWXYZ
&;!?

✳ ✳ ✳

abcdefghijklmnopqrstuvwxyz

$1234567890

Belwe Light

AABCDEFGHIJJ
KKLMMNOPQRS
TUVWXXYZ

abcdefghijjklmno
pqrstuvwxxyz
&;!?

$1234567890

Biltmore

ABCDEFGH
IJKLMNOPQR
STUVWXYZ

abcdefghijklmn
opqrstuvwxyz

$1234567890

Bodoni Open

ABCDEFGHI
JKLMNOPQRS
TUVWXYZ

abcdefghijklm
nopqrstuvwxyz
&;!?

$1234567890

Bravour Light

ABCDEFGHI
JKLMNOPQ
RSTUVWXY
Z
abcdefghijkl
mnopqrstu
vwxyz&;!?
1234567890$

Brittany Extra Light

ABCDEFGHI
JKLMNOP
QRSTUVW
XYZ (&.,:;!?"-)
abcdefghij
klmnopqr
stuvwxyz
1234567890$

Camelot

ABCDEFGHI
JKLMMMNOPQ
RRSSTUVW
XYZ&
aabcdefghhijk
lmmnopqrstu
vwxyz
$1234567890;!?

Casablanca Light

ABCDEFGHIJ
KLMNOPQRSTU
VWXYZ&;!?

abcdefghijklmno
pqrstuvwxyz

《〈〉》

1234567890$

Centaur Light

ABCDEFGHI
JKLMNOPQR
STUVWXYZ

abcdefghijklm
nopqrstuvwxyz

1234567890$&;!?

Charter Roman

ABCDEFGH
IJKLMNOPQR
STUVWXYZ

ABCDEFGHI
JKLMNOPQRS
TUVWXYZ

&;!?

$1234567890

Chevalier

ABCDEFGHIJK
LMNOPQRSTU
VWXYZZ

abcdefghijklmno
pqrstuvwxyz

$&;!?

1234567890

Codex

ABCDEFGHIJ
KLMNOPQRS
TUVWXYZ

abcdefghijklmnop
qrstuvwxyz

$1234567890 &;!?

Corvenus

ABCDEFGHIJK
LMNOPQRSTUV
WXYZ&,;!?

abcdefghijklmno
pqrstuvwxyz

1234567890$

Delphin No.1

ABCDEFGHI
JKLMNOPQR
STUVWXYZ

abcddefgghijklm
nopqrstuvw
xyz

$1234567890&;!?

Eastern Souvenir Light

ABCDEFGHIJKLMN
OPQRSTUVWXYZ
abcdefghijklmn
opqrstuvwxyz
&$;!?

1234567890

Eden Light

ABCDEFGHIJ
KLMNOPQRSTU
VWXYZ&

abcdefghijklmnop
qrstuvwxyz

1234567890$

EGMONT INLINE

ABCDEFGH

IJKLMNOP

QRSTUV

WXYZ

&!?

1234567890$

Egyptian 505 Light

ABCDEFGHIJKL

MNOPQRSTU

VWXYZ

abcdefghijklmn

opqrstuvwxyz

&&;!?

1234567890

Ehmke

AABCDEFGHIJJ
KLMNOPPQRST
TUVWXYYZ

abcdefghijklmnop
qrstuvwxyz

$1234567890&!?

Elizabeth Roman

ABCDEFGHI
JKLMNOPQRS
TUVWXYZ

abcdefghijklmnop
qrstuvwxyz

1234567890

Erasmus Light

ABCDEFGHIJ
KLMNOPQRST
UVWXYZ

abcdefghijklmno
pqrstuvwxyz

$1234567890&!?

Florentine

ABCDEFGHIJK

LMNOPQRSTUV

WXYZ&;!?

ÆBEFMNOPRS

abcdefghijklmno

pqrstuvwxyz

aeo

$1234567890

Folkwang

ABCDEFGHIJK
LMNOPQRST
UVWXYZ

abcdefghijklmnop
qrstuvwxyz

$1234567890&;!?

FORUM

ABCDEFGH
IJKLMNOP
QRSTUV
WXYZ

1234567890

Garamond Open

ABCDEFGHIJ
KLMNOPQRST
UVWXYZ

abcdefghijklmno
pqrstuvwxyz

$1234567890&;!?

GEORGIAN

ABCDE

FGHIJKL

M

NOPQRS

TUVW

XYZ

Goudy Handtooled

ABCDEFGHI
JKLMNOPQRS
TUVWXYZ

abcdefghijklmn
opqrstuvwxyz

$1234567890&;!?

Goudy Italian

ABCDEFGHIJKL
MNOPQRSTU
VWXYZ
abcdefghijklm
nopqrstuvwxyz
&;!?$

1234567890
1234567890

Goudy Text Inline

ABCDEFGHIJ
KLMNOPQRS
TUVWXYZ

&

abcdefghijklmnopqrs
tuvwxyz;!?

$1234567890

43

Goudy Thirty

ABCDEFGHIJK
LMNOPQRSTU
VWXYZ&;!?

abcdefghijklmnop
qrstuvwxyz

$1234567890

Graybar Book

ABCDEFGHIJ
KLMNOPQRST
UVWXYZ
&;?!$

abcdefghijklmn
opqrstuvwxyz

1234567890

Harper Fineline

ABCccDEFGHIJK
LLLLLLMNOPQ
RSTUVWXYZ&

abcdefghijklmn
opqrstuvwxyz

$1234567890;!?

Hiero Rhode

ABCDEFGH
IJKLMNOPQR
STUVWXYZ

abcdefghijklmn
opqrstuvwxyz

1234567890

HOBO EXTRA LIGHT

ABCDEFGHI
JKLMNOPQRS
TUVWXYZ

&?!$

1234567890

Hyperion

ABCDEFGHIJ
KLMNOPQRS
TUVWXYZ

abcdefghijklmno
pqrstuvwxyz

1234567890

Kronnen

ABCDEFGH
IJKLMNOPQR
RSTUVW
XYZ&
abcdefghijklmn
opqrstuvwxyz
r
1234567890!?

Light Litho Roman

ABCDEFGHI
JKLMNOPQR
STUVWXYZ

abcdefghijklmn
opqrstuvwxyz
&;!?

$1234567890

Lucian

ABCDEFGHIJK
LMNOPQRS
TUVWXYZ
abcdefghijkl
mnopqrstuvwxyz
&$c;!?

1234567890

Lydian

ABCDEFGHIJKLM
NOPQRSTUV
WXYZ

abcdefghijklmn
opqrstuvwxyz

$1234567890&;!?

Lynton Light

ABCDEFGH
IJKLMNOPQRS
TUVWXYZ

abcdefghijklm
nopqrstuvwxyz

1234567890&;!?

Matheis Mobil

ABCDEFGH
IJKLMNOPQR
STUVWXYZ

abcdefghijklmn
opqrstuvwxyz

1234567890

Mona Lisa

ABCDEFGHIJKL
MNOPQRSTU
VWXYZ

abcdefghijklmno
pqrstuvwxyz

$1234567890&;!?

MURAL

ABCDEFGHIJKL
MNOPQRSTU
VWXYZ

AND

$1234567890

◁&;!?▷

Musketeer

AAAABCDEFGH
HIJKLMMMNOP
QRSTUVVWXYZ

abcdefghijklmn
opqrstuvwxyz

$1234567890&:!?

NADAL'L'

ABCDEFGHI
JKL'MNOPQR
STUVWXYZ

&;!?

$1234567890

Natchez

ABCDEFGHIJKLM
NOPQRSTUVWXYZ
&;!?

abcdefghijklmn
opqrstuvwxyz

1234567890$

NATIONAL OLDSTYLE

ABCDEFGHI
JKLMNOPQR
STUVWXYZ
abcdefghijklmn
opqrstuvwxyz
.,;$&?
1234567890

Novel Gothic Light

ABCDEFGHIJK
LMNOPQRSTU
VWXYZ&;!?

abcdefghijklmno
pqrstuvwxyz

$1234567890

OLD OPEN ROMAN

ABCDEF
GHIJKLM
NOPQRS
TUVW
XYZ
&

ORBIS

ABCDEFGHIJK
LMNOPQRSTU
VWXYZ

1234567890

ORGAN GRINDER LIGHT

AaBCDEFGH
IJKLMNOPPQ
RRSSTUVWXYZ
&¡!?
1234567890$

Orinda Light

ABCDEFGHIJKL
MNOPQRSTU
VWXYZ

abcdefghijklmn
opqrstuvwxyz

$1234567890&;!?

Palace Roman

ABCDEFGHIJ
KLMNOPQRST
UVWXYZ

abcdefghijklmno
pqrstuvwxyz

&;!?$¢%

1234567890

Palace Script

A B C D E F G

H I J K L M N O P

Q R S T U V W

X Y Z

&

abcdefghijklmnopqrstuv

wxyz

1234567890

Papyrus

ABCDEFGHI
JKLMNOPQR
STUVWX
YZ

abcdefghijklmnopq
rstuvwxyz

1234567890

Perpetua Light

ABCDEFGHIJKLM
NOPQRSTU
VWXYZ
abcdefghijklmn
opqrstuvwxyz

1234567890&;!?

Players

ABCDEFGHIJ

KLMNOPQRSTUV

WXYZ&;!?

abcdefghijklm

nopqrstuvwxyz

$1234567890

Post Medieval

ABCDEFGHI
JKLMNOPQRS
TUVWXYZ
Q
abcdefghijklmnop
qrstuvwxyz
(&;!?"–"–.*)
1234567890

Post Roman Light

ABCDEFGHIJ
KLMNOPQRST
UVWXYZ

abcdefghijklm
nopqrstuvwxyz

$1234567890&,!?

Postal Light

ABCDEFGHIJK
LMNOPQRSTU
VWXYZ
abcdefghijklmn
opqrstuvwxyz

&1234567890$;!?

Pract Antiqua

ABCDEFGHI
JKLMNOPQR
STUVWXYZ

abcdefghijklmno
pqrstuvvxyz

1234567890

Quirinus

ABCDEFGHIJK
LMNOPQRSTU
VWXYZ

abcdefghijklmn
opqrstuvwxyz

&1234567890

Quorum Light

ABCDEFGHIJ
KLMNOPQRSTU
VWXYZ&:!?

abcdefghijklmn
opqrstuvwxyz

$1234567890

RIVOLI INITIALS

ABCD

EFGHHIJK

LMNOP

QRSTUVW

XYZ

Roman Compressed No. 3

ABCDEFGHIJKL
MNOPQRSTU
VWXYZ

abcdefghijklmnop
qrstuvwxyz

$1234567890&;!?

Romantic Medium

ABCDEFGHHIJKLM
NOPQRSSTUVWXYZ

aabcdeefghijk
lmnopqrsstuvwxyz

&$,!?

1234567890

Simoncini Garamond

ABCDEFGHIJ
KLMNOPQRST
UVWXYZ

✛

abcdefghijklmn
opqrstuvwxyz

❧

&✝1234567890$;!?

SOLO JASON

ABCDEFGHI

JKLMNOPQ

RSTUVW

XYZ&

!.,?

Sorbonne

ABCDEFGH
IJKLMNOPQRS
TUVWXYZ

abcdefghijklm
nopqrstuvwxy
z!?

$1234567890&

Soul Light

AAABCCDEEFFF
GGHIJKLMMNNO
PQRRSSTUVUUW
XXYZ&;!?

aabccdeefghijkl
mnopqrrssttuvuu
wxxyz

$$¢¢1234567890

Souvenir Sans Light

ABCDEFGHIJK
LMNOPQRST
UVWXYZ

abcdefghijklmn
opqrstuvwxyz

&1234567890$!?

Stacey Light

ABCDEFGHIJK
LMNOPQRS
TUVWXYZ

abcdefghijklmn
opqrstuvwxyz

&;!?$

1234567890

Stark Debonair Monobold

ABCDEFGHIJKLM
NOPQQRRSTU
VWWXYZ

abcdefgghijklmn
opqrstuvw
wxyyz

1234567890$

State House

ABCDEFGHIJK
LMNOPQRRST
UVWXYZ

aabbcddeffgghhii
jjkklmnoppqqrstt
uvwxyyyz

&

$1234567890;!?

Tabasco Light

AABCDEFGHHIJ
KKLLMMNNO
PQRRSTUUVVW
WXYYZ&;!?
abcdefghhijkkl
mnnopqrsstuv
vwwxyz

$1234567890

THERMO 300

ABCDEFG
HIJKLMNOP
QRSSTUV
WXYZ
&;!?$

1234567890

Trooper Roman Light

ABCDEFGHIJKL
MNOPQRSTUV
WXYZ&;!?

abcdefghijklmn
opqrstuvwxyz

$1234567890

Verona Humanistic

ABCDEFGHI
JKLMNOPQRS
TUVWXYZ

abcdefghijklmno
pqrstuvwxyz

$1234567890&,!?

Virgin Roman

ABCDEFGHIJK

LMNOPQRS

TUVWXYZ&

abcdefghijklmno

pqrstuvwxyz

1234567890$;!?

Virtuoso Light

ABCDEFGHI
JKLMNOPQ
QRSTUVW
XYZ

abcdefghijklmnopqrstuvw
xyz&;!?

$1234567890

WEISS LAPIDAR LIGHT

Ｚ A B C D E E F G
G H I J K L M N O P
Q R S T U V W
X Y Z

1 2 3 4 5 6 7 8 9 0

Westminster Light

ABCDEFGHIJ
KLMNOPQRST
UVWXYZ

abcdefghijklmno
pqrstuvwxyz

$1234567890&;!?

Windsor Light Condensed

ABCDEFGHIJKL
MNOPQRSTUVW
XYZ
abcdefghijklmnopq
rstuvwxyz

&

$1234567890;!?

Zachery

ABCDEFGHIJKLM
NOPQRSTUVWXYZ

abcdefghijklmnopqrs
tuvwxyz

1234567890 &;!?

Zealand

ABCDEFGH
IJKLMNOPQ
RSTUVWXYZ

abcdefghijklmmnnop
qrrstuvwxyz

1234567890&;!?

Zodiack

ABCDEFGHIJ
KLMNOPQRST
UVWXYYZ

abcdefghijklmnopqrstu
vwxyz

1234567890&:!?